'GOOD B.O.
MEANS GOOD
"BOX OFFICE".
YOU CAN SMELL
IT FROM A
MILE AWAY.'

ANDY WARHOL
Born 1928, Pittsburgh, Pennsylvania, USA
Died 1987, Manhattan, New York, USA

These pieces have been selected by the editors from
The Philosophy of Andy Warhol, first published in 1975. They
did not appear as a standalone volume in Warhol's lifetime.

WARHOL IN PENGUIN MODERN CLASSICS
America
The Andy Warhol Diaries
The Philosophy of Andy Warhol
POPism: The Warhol Sixties (with Pat Hackett)

ANDY WARHOL

Fame

PENGUIN BOOKS

PENGUIN CLASSICS

UK | USA | Canada | Ireland | Australia
India | New Zealand | South Africa

Penguin Books is part of the Penguin Random House group
of companies whose addresses can be found at
global.penguinrandomhouse.com.

Penguin
Random House
UK

This selection first published 2018
001

Set in 11.2/13.75 pt Dante MT Std
Typeset by Jouve (UK), Milton Keynes
Printed in Great Britain by Clays Ltd, St Ives plc

ISBN: 978–0–241–33980–0

www.greenpenguin.co.uk

MIX
Paper from
responsible sources
FSC® C018179
www.fsc.org

Penguin Random House is committed to a
sustainable future for our business, our readers
and our planet. This book is made from Forest
Stewardship Council® certified paper.

Contents

Love (Senility)

B: *Why didn't you show up last night? You've been in a funny mood lately.*
A: *It's just – I can't meet new people. I'm too tired.*
B: *Well, these were old people and you didn't show up. You shouldn't watch so much TV.*
A: *Oh I know.*

B: *Is that a female impersonator?*
A: *Of what?*

A: *The most exciting thing is not-doing-it. If you fall in love with someone and never do it, it's much more exciting.*

Love affairs get too involved, and they're not really worth it. But if, for some reason, you feel that they are, you should put in exactly as much time and energy as the other person. In other words, 'I'll pay you if you pay me.'

People have so many problems with love, always looking for someone to be their Via Veneto, their soufflé that can't fall. There should be a course in the first grade on love. There should be courses on beauty and love and sex. With love as the biggest course. And they should show the kids, I always think, how to make love and tell and show them once and for all how nothing it is. But they won't do that, because love and sex are business.

But then I think, maybe it works out just as well that nobody takes you out of the dark about it, because if you really knew the whole story, you wouldn't have anything to think about or fantasize about for the rest of your life,

and you might go crazy, having nothing to think about, since life is getting longer, anyway, leaving so much time after puberty to have sex in.

I don't remember much about puberty. I probably missed most of it being sick in bed with my Charlie McCarthy doll, just like I missed *Snow White*. I didn't see *Snow White* until I was forty-five, when I went with Roman Polanski to see it at Lincoln Center. It was probably a good thing that I waited, because I can't imagine how it could ever be more exciting than it was then. Which gave me the idea that instead of telling kids very early about the mechanics and nothingness of sex, maybe it would be better to suddenly and very excitingly reveal the details to them when they're forty. You could be walking down the street with a friend who's just turned forty, spill the birds-and-the-bees beans, wait for the initial shock of learning what-goes-where to die down, and then patiently explain the rest. Then suddenly at forty their life would have new meaning. We should really stay babies for much longer than we do, now that we're living so much longer.

It's the long life-spans that are throwing all the old values and their applications out of whack. When people used to learn about sex at fifteen and die at thirty-five, they obviously were going to have fewer problems than people today who learn about sex at eight or so, I guess,

and live to be eighty. That's a long time to play around with the same concept. The same boring concept.

Parents who really love their kids and want them to be bored and discontented for as small a percentage of their lifetimes as possible maybe should go back to not letting them date until as late as possible so they have something to look forward to for a longer time.

Sex is more exciting on the screen and between the pages than between the sheets anyway. Let the kids read about it and look forward to it, and then right before they're going to get the reality, break the news to them that they've already had the most exciting part, that it's behind them already.

Fantasy love is much better than reality love. Never doing it is very exciting. The most exciting attractions are between two opposites that never meet.

I love every 'lib' movement there is, because after the 'lib' the things that were always a mystique become understandable and boring, and then nobody has to feel left out if they're not part of what is happening. For instance, single people looking for husbands and wives used to feel left out because the image marriage had in the old days was so wonderful. Jane Wyatt and Robert Young. Nick

and Nora Charles. Ethel and Fred Mertz. Dagwood and Blondie.

Being married looked so wonderful that life didn't seem livable if you weren't lucky enough to have a husband or wife. To the singles, marriage seemed beautiful, the trappings seemed wonderful, and the sex was always implied to be automatically great – no one could ever seem to find words to describe it because 'you had to be there' to know how good it was. It was almost like a conspiracy on the part of the married people not to let it out how it wasn't necessarily completely wonderful to be married and having sex; they could have taken a load off the single people's minds if they'd just been candid.

But it was always a fairly well-kept secret that if you were married to somebody you didn't have enough room in bed and might have to face bad breath in the morning.

There are so many songs about love. But I was thrilled the other day when somebody mailed me the lyrics to a song that was about how he didn't care about anything, and how he didn't care about me. It was very good. He managed to really convey the idea that he really didn't care.

I don't see anything wrong with being alone. It feels great to me. People make a big thing about personal love. It doesn't have to be such a big thing. The same for

living – people make a big thing about that too. But personal living and personal loving are the two things the Eastern-type wise men *don't* think about.

I wonder if it's possible to have a love affair that lasts forever. If you're married for thirty years and you're 'cooking breakfast for the one you love' and he walks in, does his heart really skip a beat? I mean if it's just a regular morning. I guess it skips a beat over that breakfast and that's nice, too. It's nice to have a little breakfast made for you.

The biggest price you pay for love is that you have to have somebody around, you can't be on your own, which is always so much better. The biggest disadvantage, of course, is no room in bed. Even a pet cuts into your bed room.

I believe in long engagements. The longer, the better.

Love and sex can go together and sex and unlove can go together and love and unsex can go together. But personal love and personal sex is bad.

You can be just as faithful to a place or a thing as you can to a person. A place can really make your heart skip a beat, especially if you have to take a plane to get there.

*

Mom always said not to worry about love, but just to be sure to get married. But I always knew that I would never get married, because I don't want any children, I don't want them to have the same problems that I have. I don't think anybody deserves it.

I think a lot about the people who are supposed to not have any problems, who get married and live and die and it's all been wonderful. I don't know anybody like that. They always have some problem, even if it's only that the toilet doesn't flush.

My ideal wife would have a lot of bacon, bring it all home, and have a TV station besides.

I was always fascinated when I watched old war movies where the girls get married by proxy over the phone to husbands across the sea and they'd say, 'I hear you, my darling!' and I always thought how great it would be if they just stayed that way, they'd be so happy. I guess they wanted the monthly check, though.

I have a telephone mate. We've had an on-going relation-ship over the phone for six years. I live uptown and she lives downtown. It's a wonderful arrangement: we don't have to get each other's bad morning breath, yet we have

wonderful breakfasts together every morning like every other happy couple. I'm uptown in the kitchen making myself peppermint tea and a dry, medium-to-dark English muffin with marmalade, and she's downtown waiting for the coffee shop to deliver a light coffee and a toasted roll with honey and butter – heavy on the light, honey, butter, and seeds. We while and talk away the sunny morning hours with the telephone nestled between head and shoulders and we can walk away or even hang up whenever we want to. We don't have to worry about kids, just about extension phones. We have an understanding. She married a staple-gun queen twelve years ago and has been more or less waiting for the annulment to come through ever since, although she tells people who ask that he died in a mudslide.

The symptom of love is when some of the chemicals inside you go bad. So there must be something in love because your chemicals do tell you something.

I tried and tried when I was younger to learn something about love, and since it wasn't taught in school I turned to the movies for some clues about what love is and what to do about it. In those days you did learn something about some kind of love from the movies, but it was nothing you could apply with any reasonable results. I

mean, the other night I was watching on TV the 1961 version of *Back Street* with John Gavin and Susan Hayward and I was stunned the whole time because all they kept saying was how wonderful every precious moment they had together was, and so every precious moment was a testimonial to every precious moment.

But I always thought that movies could show you so much more about how it really is between people and therefore help all the people who don't understand to know what to do, what some of their options are.

What I was actually trying to do in my early movies was show how people can meet other people and what they can do and what they can say to each other. That was the whole idea: two people getting acquainted. And then when you saw it and you saw the sheer simplicity of it, you learned what it was all about. Those movies showed you how some people act and react with other people. They were like actual sociological 'For instance's. They were like documentaries, and if you thought it could apply to you, it was an example, and if it didn't apply to you, at least it was a documentary, it could apply to somebody you knew and it could clear up some questions you had about them.

In *Tub Girls*, for example, the girls had to take baths with people in tubs, and they learned how to take baths with other people. While we were doing *Tub Girls*. They

met in a tub. And the girl would have to carry her tub to the next person she'd have to take a bath with, so she'd put her tub under her arm and carry her tub . . . We used a clear plastic tub.

I never particularly wanted to make simply sex movies. If I had wanted to make a real sex movie I would have filmed a flower giving birth to another flower. And the best love story is just two love-birds in a cage.

The best love is not-to-think-about-it love. Some people can have sex and really let their minds go blank and fill up with the sex; other people can never let their minds go blank and fill up with the sex, so while they're having the sex they're thinking, 'Can this really be me? Am I really doing this? This is very strange. Five minutes ago I wasn't doing this. In a little while I won't be doing it. What would Mom say? How did people ever think of doing this?' So the first type of person – the type that can let their minds go blank and fill up with sex and not-think-about-it – is better off. The other type has to find something else to relax with and get lost in. For me that something else is humor.

Funny people are the only people I ever get really interested in, because as soon as somebody isn't funny, they bore me. But if the big attraction for you is having somebody be funny, you run into a problem, because

being funny is not being sexy, so in the end, near the moment of truth, you're not really attracted, you can't really 'do it'.

But I'd rather laugh in bed than do it. Get under the covers and crack jokes, I guess, is the best way. 'How am I doing?' 'Fine, that was very funny.' 'Wow, you were really funny tonight.'

If I went to a lady of the night, I'd probably pay her to tell me jokes.

Sometimes sex doesn't wear off. I've seen cases of couples where the sex for each other didn't wear off over the years.

Couples do become like each other when they're together for a long time, because you like the person and you pick up their mannerisms and their little good habits. And you eat the same food.

Everybody has a different idea of love. One girl I know said, 'I knew he loved me when he didn't come in my mouth.'

Over the years I've been more successful at dealing with love than with jealousy. I get jealousy attacks all the time. I think I may be one of the most jealous people in the world. My right hand is jealous if my left hand is painting a pretty picture. If my left leg is dancing a good step, my

right leg gets jealous. The left side of my mouth is jealous when my right side is eating something good. I'm jealous at dinner that somebody else will think of something better to order than I did. I'm jealous of somebody's blurred Instamatics even when I have my own sharp Polaroids of the same scene. Basically, I go crazy when I can't have first choice on absolutely everything. A lot of times I do things I don't want to do at all, just because I'm on stand-by jealousy that somebody else will get to do it instead. As a matter of fact, I'm always trying to buy things and people just because I'm so jealous somebody else might buy them and they might turn out to be good after all. That's one of the stories of my life. And the few times in my life when I've gone on television, I've been so jealous of the host on the show that I haven't been able to talk. As soon as the TV cameras turn on, all I can think is, 'I want my own show . . . I want my own show.'

I get very nervous when I think someone is falling in love with me. Every time I have a 'romance' I'm so nervous I bring the whole office with me. That's usually about five or six people. They all come to pick me up and then we go to pick her up. Love me, love my office.

Everybody winds up kissing the wrong person good-night. One of my ways of thanking the office for coming

with me to chaperone is to make myself available to
chaperone their dates. One or two of them like to take
advantage of that service, because one or two of them
are a little like me, they don't want anything to happen.
When *I'm* there, they tell me, nothing happens. I
make nothing happen. Wherever I go. I can tell when one
of them is glad to see me walk in the door, because
something's happening and they can't wait for me to
make nothing happen. Especially when they're stranded
in Italy, because you know how the Italians like to make
something happen. I'm the obvious antidote.

People should fall in love with their eyes closed. Just
close your eyes. Don't look.

Some people I know spend a lot of time trying to
dream up new seductions. I used to think that only the
people who didn't work had time to think about those
kinds of things but then I realized that most people
are using somebody else's time to dream up their new
seductions. Most of the people in offices are actually
getting paid while they day-dream up their new
seductions.

I believe in low lights and trick mirrors. A person is
entitled to the lighting they need. Plus, if you learn

about sex when you're forty, as suggested earlier, you'd better believe in low lights and trick mirrors.

Love can be bought and sold. One of the older superstars used to cry every time somebody she loved kicked her out of his loft, and I used to tell her, 'Don't worry. You're going to be very famous someday and you'll be able to buy him.' It worked out just that way and she's very happy now.

Brigitte Bardot was one of the first women to be really modern and treat men like love objects, buying them and discarding them. I like that.

The most fashionable girls around town now are the girls of the night. They wear the most fashionable clothes. They were always behind the times, looking old-fashioned, but now they're the first ones on the street with the new clothes. They wised up. More intelligent girls are girls of the night now, too. More liberated. But they all still use those ugly shoulder pocketbooks.

Sex-and-nostalgia is funny to think about. I was walking on the West Side in the Forties, around the honky tonks and I was looking at the 8 × 10 glossies of girls that they put out front. One window-case display had a very 50s look but the pictures weren't yellow with age or

anything, so I couldn't tell if those exact girls were inside right then or if that was an old picture left over and the girls inside, instead of being Mamie Van Doren types, were tired ex-hippies. I didn't know. The establishment might have been catering to a crowd who were nostalgic for all the girls they'd tried to pick up in the 50s.

With everything changing so fast, you don't have a chance of finding your fantasy image intact by the time you're ready for it. What about all the little boys who used to have fantasies about girls in beautiful lace bras and silk slips? They don't have a chance of finding what they'd always looked forward to, unless the girl had just made a trip to the local thrift shop, and that's worse than nothing.

Fantasy and clothes go together a lot, but the times and mores have thrown that off, too. When clothes-makers were making good clothes out of good materials, an ordinary guy who bought a suit or a shirt without giving too much thought to anything except 'Does it fit?' would be likely to come away with a nice-looking suit with good detailing out of a nice piece of material.

But then labor got expensive and the manufacturers began giving a little less good workmanship for the

money every year, and nobody really complained, so they pushed – and they're still pushing to the limit – how little they can give before people will say, 'Is this a shirt?' The moderate-priced clothes-makers really are giving people junk these days. On top of the awful way the clothes are made – long stitches, no linings, no darts, no finished seams – they're made out of synthetics that look awful from the first to the last wearing. (The only good synthetic is nylon, I think.)

No, a person has to be very careful about what he's buying these days or else he'll wind up buying junk. And paying a lot for it too. So this means that *if you see a well-dressed person today, you know that they've thought a lot about their clothes and how they look*. And then that ruins it because you shouldn't really be thinking about how you look so much. The same applies to girls but not as much – they can care a little more about themselves without being unattractively self-interested, because they're naturally prettier. But a man caring about how he looks is usually trying very hard to be attractive, and that's very unattractive in a man.

So today, if you see a person who looks like your teenage fantasy walking down the street, it's probably not your fantasy, but someone who had the same fantasy as you and decided instead of getting it or being it, to *look like*

it, and so he went to the store and bought the look that you both like. So forget it.

Just think about all the James Deans and what it means.

Truman Capote told me once that certain kinds of sex are total, complete manifestations of nostalgia, and I think that's true. Other kinds of sex have nostalgia in varying degrees, from a little to a lot, but I think it's safe to say that most sex involves some form of nostalgia for something.

Sex is a nostalgia for when you used to want it, sometimes.

Sex is nostalgia for sex.

Some people think violence is sexy, but I could never see that.

'Love' used to have a good number always in Mom's dream book. When I was little Mom used to play the numbers and I remember she used to have a dream book and she'd look up her dream and the book would tell her whether it was a good dream or not, and there were numbers after it which she played. And 'Love' dreams always had a good number.

*

When you want to be like something, it means you really love it. When you want to be like a rock, you really love that rock. I love plastic idols.

People with pretty smiles fascinate me. You have to wonder what makes them smile so pretty.

People look the most kissable when they're not wearing makeup. Marilyn's lips weren't kissable, but they were very photographable.

One of my movies, *Women in Revolt*, was originally entitled *Sex*, I can't now remember why we changed its name. The three female leads were three female impersonators – Candy Darling, Jackie Curtis, and Holly Woodlawn. They played women in varying degrees and various stages of 'liberation'.

Among other things, drag queens are living testimony to the way women used to want to be, the way some people still want them to be, and the way some women still actually want to be. Drags are ambulatory archives of ideal moviestar womanhood. They perform a documentary service, usually consecrating their lives to keeping the glittering alternative alive and available for (not-too-close) inspection.

To get a private room in a hospital you used to have

to be very rich but now you can get one if you're a drag queen. If you're a drag queen they want to isolate you from the other patients, but maybe they have enough for a ward now.

I'm fascinated by boys who spend their lives trying to be complete girls, because they have to work so hard – double-time – getting rid of all the tell-tale male signs and drawing in all the female signs. I'm not saying it's the right thing to do, I'm not saying it's a good idea, I'm not saying it's not self-defeating and self-destructive, and I'm not saying it's not possibly the single most absurd thing a man can do with his life. What I'm saying is, it is very hard work. You can't take that away from them. It's hard work to look like the complete opposite of what nature made you and then to be an imitation woman of what was only a fantasy woman in the first place. When they took the movie stars and stuck them in the kitchen, they weren't stars any more – they were just like you and me. Drag queens are reminders that some stars still aren't just like you and me.

For a while we were casting a lot of drag queens in our movies because the real girls we knew couldn't seem to get excited about anything, and the drag queens could get excited about anything. But lately the girls seem to be getting their energy back, so we've been using real ones a lot again.

<p align="center">★</p>

In *Women in Revolt*, Jackie Curtis ad-libbed one of the best lines of disillusionment with sex when he-as-she, portraying a virgin schoolteacher from Bayonne, New Jersey, was forced to give oral gratification – a blow-job – to Mr America. After gagging and somehow finishing up, poor Jackie can't figure out if she's had sex or not – 'This can't be what millions of girls commit suicide over when their boy-friends leave them . . .' Jackie was acting out the puzzled thoughts so many people have when they realize that sex is hard work just like every- thing else.

People's fantasies are what give them problems. If you didn't have fantasies you wouldn't have problems because you'd just take whatever was there. But then you wouldn't have romance, because romance is finding your fantasy in people who don't have it. A friend of mine always says, 'Women love me for the man I'm not.'

It's very easy to make *faux pas* when you're talking to a person who's in love, because they're more sensitive about everything. I remember once I was at a dinner party and I was talking to a couple who looked so happy together and I said, 'You are the happiest-looking couple I've ever seen.' That was okay and then I went that little bit further to score my nightly *faux pas*. 'It must have been

like a storybook dream love story. I just know you were childhood sweethearts.' And at that point their faces fell and they turned away and avoided me for the rest of the evening. I found out later that they had deserted their husbands and wives and families to go after each other.

So you really have to watch what you say to people about their love lives. When people are in love all their problems are in strange proportions and it's hard to know when you're saying the wrong thing.

To think about the love problems of people you know is really strange, because their love problems are so different from their life problems.

A drag queen I know is waiting for a real man to fall in love with him/her.

I always run into strong women who are looking for weak men to dominate them.

I don't know anybody who doesn't have a fantasy. Everybody must have a fantasy.

A movie producer friend of mine hit on something when he said, 'Frigid people can really make out.' He's right: they really can and they really do.

Beauty

B: *Does she wear someone's clothes or does she just get them herself?*

A: *Oh no no no no. She wears her husband's clothes – she goes to the same tailor. That's what they fight about.*

I've never met a person I couldn't call a beauty.

Every person has beauty at some point in their lifetime. Usually in different degrees. Sometimes they have the looks when they're a baby and they don't have it when they're grown up, but then they could get it back again when they're older. Or they might be fat but have a beautiful face. Or have bow-legs but a beautiful body. Or be the number one female beauty and have no tits. Or be the number one male beauty and have a small you-know-what.

Some people think it's easier for beauties, but actually it can work out a lot of different ways. If you're beautiful you might have a pea-brain. If you're not beautiful you might not have a pea-brain, so it depends on the pea-brain and the beauty. The size of the beauty. And the pea-brain.

I always hear myself saying, 'She's a beauty!' or 'He's a beauty!' or 'What a beauty!' but I never know what I'm talking about. I honestly don't know what beauty is, not

to speak of what 'a' beauty is. So that leaves me in a strange position, because I'm noted for how much I talk about 'this one's a beauty' and 'that one's a beauty'. For a year once it was in all the magazines that my next movie was going to be *The Beauties*. The publicity for it was great, but then I could never decide who should be in it. If everybody's not a beauty, then nobody is, so I didn't want to imply that the kids in *The Beauties* were beauties but the kids in my other movies weren't so I had to back out on the basis of the title. It was all wrong.

I really don't care that much about 'Beauties'. What I really like are Talkers. To me, good talkers are beautiful because good talk is what I love. The word itself shows why I like Talkers better than Beauties, why I tape more than I film. It's not 'talkies'. Talk*ers* are *doing* something. Beaut*ies* are *being* something. Which isn't necessarily bad, it's just that I don't know what it is they're being. It's more fun to be with people who are doing things.

When I did my self-portrait, I left all the pimples out because you always should. Pimples are a temporary condition and they don't have anything to do with what you really look like. Always omit the blemishes – they're not part of the good picture you want.

*

When a person is the beauty of their day, and their looks are really in style, and then the times change and tastes change, and ten years go by, if they keep exactly their same look and don't change anything and if they take care of themselves, they'll still be a beauty.

Schrafft's restaurants were the beauties of their day, and then they tried to keep up with the times and they modified and modified until they lost all their charm and were bought by a big company. But if they could just have kept their same look and style, and held on through the lean years when they weren't in style, today they'd be the best thing around. You have to hang on in periods when your style isn't popular, because if it's good, it'll come back, and you'll be a recognized beauty once again.

Some kind of beauty dwarfs you and makes you feel like an ant next to it. I was once in Mussolini Stadium with all the statues and they were so much bigger than life and I felt just like an ant. I was painting a beauty this afternoon and my paint caught a little bug. I tried to get the paint off the bug and I kept trying until I killed the bug on the beauty's lip. So there was this bug, that could have been a beauty, left on somebody's lip. That's the way I felt in Mussolini Stadium. Like a bug.

*

Beauties in photographs are different from beauties in person. It must be hard to be a model, because you'd want to be like the photograph of you, and you can't ever look that way. And so you start to copy the photograph. Photographs usually bring in another half-dimension. (Movies bring in another whole dimension. That screen magnetism is something secret – if you could only figure out what it is and how to make it, you'd have a really good product to sell. But you can't even tell if someone has it until you actually see them up there on the screen. You have to give screen tests to find out.)

Very few Beauties are Talkers, but there are a few.

> Beauty sleep. Sleeping beauty.
> Beauty problems. Problem beauties.

Even beauties can be unattractive. If you catch a beauty in the wrong light at the right time, forget it.
 I believe in low lights and trick mirrors.
 I believe in plastic surgery.

At one time the way my nose looked really bothered me – it's always red – and I decided that I wanted to have it sanded. Even the people in my family called me 'Andy the Red-Nosed Warhola'. I went to see the doctor and I think he thought he'd humor me, so he sanded it, and

when I walked out of St Luke's Hospital I was the same underneath, but I had a bandage on.

They don't put you to sleep but they spray frozen stuff all over your face from a spray can. Then they take a sandpaperer and spin it around all over your face. It's very painful afterwards. You stay in for two weeks waiting for the scab to fall off. I did all that and it actually made my pores bigger. I was really disappointed.

I had another skin problem, too – I lost all my pigment when I was eight years old. Another name people used to call me was 'Spot'. This is how I think I lost my pigment: I saw a girl walking down the street and she was two-toned and I was so fascinated I kept following her. Within two months I was two-toned myself. And I hadn't even known the girl – she was just somebody I saw on the street. I asked a medical student if he thought I caught it just by looking at her. He didn't say anything.

About twenty years ago I went to Georgette Klinger's Skin Clinic and Georgette turned me down. It was before she had a men's department and she discriminated against me.

If people want to spend their whole lives creaming and tweezing and brushing and tilting and gluing, that's really okay too, because it gives them something to do.

★

Sometimes people having nervous breakdown problems can look very beautiful because they have that fragile something to the way they move or walk. They put out a mood that makes them more beautiful.

People tell me that some beauties lose their looks in bed when they don't do the bed things they're supposed to. I don't believe those things.

When you're interested in somebody, and you think they might be interested in you, you should point out all your beauty problems and defects right away, rather than take a chance they won't notice them. Maybe, say, you have a permanent beauty problem you can't change, such as too-short legs. Just say it. 'My legs, as you've probably noticed, are much too short in proportion to the rest of my body.' Why give the other person the satisfaction of discovering it for themselves? Once it's out in the open, at least you know it will never become an issue later on in the relationship, and if it does, you can always say, 'Well I told you that in the beginning.'

 On the other hand, say you have a purely temporary beauty problem – a new pimple, lackluster hair, no-sleep eyes, five extra pounds around the middle. Still, whatever it is, you should point it out. If you don't point it out and say, 'My hair is really dull this time of the month, I'm

probably getting my friend', or 'I put on five pounds eating Russell Stover chocolates over Christmas, but I'm taking it off right away' – if you don't point out these things they might think that your temporary beauty problem is a permanent beauty problem. Why should they think otherwise if you've just met them? Remember, they've never seen you before in their life. So it's up to you to set them straight and get them to use their imagination about what your hair must look like when it's shiny, and what your body must look like when it's not overweight, and what your dress would look like without the grease spot on it. Even explain that you have much better clothes hanging in your closet than the ones you're wearing. If they really do like you for yourself, they'll be willing to use their imagination to think of what you must look like without your temporary beauty problem.

If you're naturally pale, you should put on a lot of blush-on to compensate. But if you've got a big nose, just play it up, and if you have a pimple, put on the pimple cream in a way that will make it really stand out – 'There! I use pimple cream!' There's a difference.

I always think that when people turn around to look at somebody on the street it's probably that they smell an

odor from them, and that's what makes them turn around and on.

Diana Vreeland, the editor of *Vogue* for ten years, is one of the most beautiful women in the world because she's not afraid of other people, she does what she wants. Truman Capote brought up something else about her – she's very very clean, and that makes her more beautiful. Maybe it's even the basis of her beauty.

Being clean is so important. Well-groomed people are the real beauties. It doesn't matter what they're wearing or who they're with or how much their jewelry costs or how much their clothes cost or how perfect their makeup is: if they're not clean, they're not beautiful. The most plain or unfashionable person in the world can still be beautiful if they're very well-groomed.

During the 60s a lot of people I knew seemed to think that underarm smell was attractive. They never seemed to be wearing anything washable. Everything always had to be dry-cleaned – the satins, the sewn-on mirrors, the velvets – the problem was that it never was dry-cleaned. And then it got worse when everybody was wearing suedes and leathers, and those *really* never got cleaned. I admit to having worn suede and leather pants myself for a while, but

you just never feel clean, and it's degenerate, anyway, to wear animal skins unless it's to keep yourself warm. I'll never understand why they haven't invented something yet that's as warm as fur. So I went back to bluejeans after that degenerate period. Very happily. Bluejeans wind up being the cleanest thing you can wear, because it's just their nature to be washed a lot. And they're so American in essence.

Beauty really has to do with the way a person carries it off. When you see 'beauty', it has to do with the place, with what they're wearing, what they're standing next to, what closet they're coming down the stairs from.

Jewelry doesn't make a person more beautiful, but it makes a person *feel* more beautiful. If you draped a beautiful person in jewels and beautiful clothes and put them in a beautiful house with beautiful furniture and beautiful paintings, they wouldn't be more beautiful, they'd be the same, but they would *think* they were more beautiful. However, if you took a beautiful person and put them in rags, they'd be ugly. You can always make a person less beautiful.

Beauty in danger becomes more beautiful, but beauty in dirt becomes ugly.

<div align="center">★</div>

What makes a painting beautiful is the way the paint's put on, but I don't understand how women put on makeup. It gets on your lips, and it's so heavy. Lipstick and makeup and powder and shadow creams. And jewelry. It's all so heavy.

Children are always beautiful. Every kid, up to, say, eight years old always looks good. Even if the kid wears glasses it still looks good. They always have the perfect nose. I've never seen an unattractive baby. Small features and nice skin. This also applies to animals – I've never seen a bad-looking animal. Babies by being beautiful are protected because people want less to hurt them. This applies also to all animals.

Beauty doesn't have anything to do with sex. Beauty has to do with beauty and sex has to do with sex.

If a person isn't generally considered beautiful, they can still be a success if they have a few jokes in their pockets. And a lot of pockets.

Beautiful people are sometimes more prone to keep you waiting than plain people are, because there's a big time differential between beautiful and plain. Also, beauties know that most people will wait for them, so they're not

panicked when they're late, so they get even later. But by the time they arrive, they've usually gotten to feel guilty, so then to make up for being late they get really sweet, and being really sweet makes them more beautiful. That's a classic syndrome.

I'm always trying to figure out whether if a woman is funny, she can still be beautiful. There are some very attractive comediennes, but if you had to choose between calling them beautiful and calling them funny, you'd call them funny. Sometimes I think that *extreme* beauty must be absolutely humorless. But then I think of Marilyn Monroe and she had the best funny lines. She might have been a lot of fun if she'd found the right comedy niche. We might be laughing at skits on 'The Marilyn Monroe Show' today.

Someone once asked me to state once and for all the most beautiful person I'd ever met. Well, the only people I can ever pick out as unequivocal beauties are from the movies, and then when you meet them, they're not really beauties either, so your standards don't even really exist. In life, the movie stars can't even come up to the standards they set on film.

Some of the very beautiful film stars of the past decades have aged beautifully and some have aged not-so-

beautifully, and sometimes you see two stars together today who were once beautiful together in the same movie a long time ago, and now one of them looks and acts like an old woman and the other still looks and acts like a girl. But all of that doesn't matter very much, I think, because history will remember each person only for their beautiful moments on film – the rest is off-the-record.

A good plain look is my favorite look. If I didn't want to look so 'bad', I would want to look 'plain'. That would be my next choice.

I always think about what it means to wear eyeglasses. When you get used to glasses you don't know how far you could really see. I think about all the people before eyeglasses were invented. It must have been weird because everyone was seeing in different ways according to how bad their eyes were. Now, eyeglasses standardize everyone's vision to 20-20. That's an example of everyone becoming more alike. Everyone could be seeing at different levels if it weren't for glasses.

In some circles where very heavy people think they have very heavy brains, words like 'charming' and 'clever' and 'pretty' are all put-downs; all the lighter

things in life, which are the most important things, are put down.

Weight isn't important the way the magazines make you think it is. I know a girl who just looks at her face in the medicine cabinet mirror and never looks below her shoulders, and she's four or five hundred pounds but she doesn't see all that, she just sees a beautiful face and therefore she thinks she's a beauty. And therefore I think she's a beauty, too, because I usually accept people on the basis of their self-images, because their self-images have more to do with the way they think than their objective-images do. Maybe she's six hundred pounds, who knows. If she doesn't care, I don't.

But if you do watch your weight, try the Andy Warhol New York City Diet: when I order in a restaurant, I order everything that I don't want, so I have a lot to play around with while everyone else eats. Then, no matter how chic the restaurant is, I insist that the waiter wrap the entire plate up like a to-go order, and after we leave the restaurant I find a little corner outside in the street to leave the plate in, because there are so many people in New York who live in the streets, with everything they own in shopping bags.

So I lose weight and stay trim, and I think that maybe one of those people will find a Grenouille dinner on the

window ledge. But then, you never know, maybe they wouldn't like what I ordered as much as I didn't like it, and maybe they'd turn up their noses and look through the garbage for some half-eaten rye bread. You just never know with people. You just never know what they'll like, what you should do for them.

So that's the Andy Warhol New York City Diet.

I know good cooks who'll spend days finding fresh garlic and fresh basil and fresh tarragon, etc., and then use canned tomatoes for the sauce, saying it doesn't matter. But I know it does matter.

Whenever people and civilizations get degenerate and materialistic, they always point at their outward beauty and riches and say that if what they were doing was bad, they wouldn't be doing so well, being so rich and beautiful. People in the Bible did that when they worshiped the Golden Calf, for example, and then the Greeks when they worshiped the human body. But beauty and riches couldn't have anything to do with how good you are, because think of all the beauties who get cancer. And a lot of murderers are good-looking, so that settles it.

Some people, even intelligent people, say that violence can be beautiful. I can't understand that, because

beautiful is some moments, and for me those moments are never violent.

A new idea.
 A new look.
 A new sex.
 A new pair of underwear.

There should be a lot of new girls in town, and there always are.

The red lobster's beauty only comes out when it's dropped into the boiling water . . . and nature changes things and carbon is turned into diamonds and dirt is gold . . . and wearing a ring in your nose is gorgeous.

I can never get over when you're on the beach how beautiful the sand looks and the water washes it away and straightens it up and the trees and the grass all look great. I think having land and not ruining it is the most beautiful art that anybody could ever want to own.

The most beautiful thing in Tokyo is McDonald's.

The most beautiful thing in Stockholm is McDonald's.

*

The most beautiful thing in Florence is McDonald's.

Peking and Moscow don't have anything beautiful yet.

America is really The Beautiful. But it would be more beautiful if everybody had enough money to live.

Beautiful jails for Beautiful People.

Everybody's sense of beauty is different from everybody else's. When I see people dressed in hideous clothes that look all wrong on them, I try to imagine the moment when they were buying them and thought, 'This is great. I like it. I'll take it.' You can't imagine what went off in their heads to make them buy those maroon polyester waffle-iron pants or that acrylic halter top that has 'Miami' written in glitter. You wonder what they rejected as *not* beautiful – an acrylic halter top that had 'Chicago'?

You can never predict what little things in the way somebody looks or talks or acts will set off peculiar emotional reactions in other people. For instance, the other night I was with a lady who suddenly got very intense about a person we both knew and she started to tear apart his looks – his weak arms, his pimply face, his bad posture, his thick eyebrows, his big nose, his bad clothes, and I

didn't know what to say because I didn't see why she would be seen with me if she wouldn't be seen with him. After all, I have weak arms, I have pimples, but she didn't seem to notice my problems. I think that some little thing can set off reactions in people, and you don't know what it is in their past that's making them like or not like somebody so much and therefore like or not like everything about them.

Sometimes something can look beautiful just because it's different in some way from the other things around it. One red petunia in a window box will look very beautiful if all the rest of them are white, and vice-versa.

When you're in Sweden and you see beautiful person after beautiful person after beautiful person and you finally don't even turn around to look because you know the next person you see will be just as beautiful as the one you didn't bother to turn around to look at – in a place like that you can get so bored that when you see a person who's not beautiful, they look very beautiful to you because they break the beautiful monotony.

There are three things that always look very beautiful to me: my same good pair of old shoes that don't hurt, my own bedroom, and U.S. Customs on the way back home.

Fame

B: *What did those record people want?*

A: *They want me to cut a record. They'll make my voice sound like it's singing.*

A: *I love your* Daily News *commercial on television. I've seen it fifteen times.*

Some company recently was interested in buying my 'aura'. They didn't want my product. They kept saying, 'We want your aura.' I never figured out what they wanted. But they were willing to pay a lot for it. So then I thought that if somebody was willing to pay that much for my it, I should try to figure out what it is.

I think 'aura' is something that only somebody else can see, and they only see as much of it as they want to. It's all in the other person's eyes. You can only see an aura on people you don't know very well or don't know at all. I was having dinner the other night with everybody from my office. The kids at the office treat me like dirt, because they know me and they see me every day. But then there was this nice friend that somebody had brought along who had never met me, and this kid could hardly believe that he was having dinner with me! Everybody else was seeing me, but he was seeing my 'aura'.

When you just see somebody on the street, they can really have an aura. But then when they open their

mouth, there goes the aura. 'Aura' must be until you open your mouth.

The people who have the best fame are those who have their name on stores. The people with very big stores named after them are the ones I'm really jealous of. Like Marshall Field.

But being famous isn't all that important. If I weren't famous, I wouldn't have been shot for being Andy Warhol. Maybe I would have been shot for being in the Army. Or maybe I would be a fat schoolteacher. How do you ever know?

A good reason to be famous, though, is so you can read all the big magazines and know everybody in all the stories. Page after page it's just all people you've met. I love that kind of reading experience and that's the best reason to be famous.

I'm confused about who the news belongs to. I always have it in my head that if your name's in the news, then the news should be paying you. Because it's *your news* and they're taking it and selling it as their product. But then they always say that they're helping you, and that's true too, but still, if people didn't give the news their news, and if everybody kept their news to themselves,

the news wouldn't have any news. So I guess you should pay each other. But I haven't figured it out fully yet.

The worst, most cruel review of me that I ever read was the *Time* magazine review of me getting shot.

I've found that almost all interviews are preordained. They know what they want to write about you and they know what they think about you before they ever talk to you, so they're just looking for words and details from here and there to back up what they've already decided they're going to say. If you go into an interview blind, there is absolutely no way of guessing what kind of article the person you're talking to is going to write. The nicest, laughingest people can write the meanest articles, and the people you think are hating you can write the funniest, nicest articles. It's harder to tell with journalists than with politicians.

When somebody writes a really mean article, I always just let it go by because who are you to say it isn't the truth?

People used to say that I tried to 'put on' the media when I would give one autobiography to one newspaper and another autobiography to another newspaper. I used to like to give different information to different magazines because it was like putting a tracer on where people get their information. That way I could always tell when I met people what newspapers and magazines

they were reading by the things they would tell me I had said. Sometimes funny pieces of information come back to you years and years later when an interviewer says, 'You once said that Lefrak City was the most beautiful place in the world', and then you know that they've read what you once told *Architectural Forum*.

The right story in the right place can really put you up-there for months or even years. I lived next to a Gristedes grocery for twelve years, and every day I would go in and drift around the aisles, picking out what I wanted – that's a ritual I really enjoy. For twelve years I did this just about every day. Then one afternoon the New York *Post* ran a color picture of Monique Van Vooren and Rudolf Nureyev and me on the front page, and when I next went into the store all the stockboys started yelling 'Here he is!' and 'I told you it was him!' I didn't want to go back there ever again. Then after my picture was in *Time*, I couldn't take my dog to the park for a week because people were pointing at me.

Up until a year ago I was a real nobody in Italy. I was somebody – maybe – in Germany and England – which is why I no longer go to those countries – but in Italy they couldn't even spell my name. Then *L'Uomo Vogue* found out how to spell my name from a superstar of ours who started going with one of their photographers – pillow

talk I guess – but anyway, he leaked the correct spelling of my name to *L'Uomo* and then he leaked the titles of my movies and photos of my paintings and now I'm a fad in Italy. In fact, I was just in a very small town called Boissano, on the wrong side of the Riviera, and I was having an aperitif on the terrace of the local newsstand and a young fellow, a high school student, came up to me and said, 'Hi, Andy, how's Holly Woodlawn doing?' I was shocked. He knew about five words of English and four of them were FLESH, TRASH, HEAT, and DALLESANDRO, which maybe doesn't count because it's Italian.

I'm always interested in talk-show hosts. A person I know told me he can look at people who do interviews on television and know where they're from, what kind of schools they went to, what religion they are, just by seeing what kind of guests they have on their show and by hearing what kind of questions they ask their guests. I'd love to be able to know everything about a person from watching them on television – to be able to tell *what their problem is*. Can you imagine watching a talk show and knowing immediately things like –

> 'This one's problem is HE WANTS TO BE A BEAUTY.'

'This one's problem is HE HATES RICH
 PEOPLE.'
'This one's problem is HE CAN'T GET IT UP.'
'That one's problem is HE WANTS TO BE
 MISERABLE.'
'This one's problem is HE WANTS TO BE
 INTELLIGENT.'

And maybe you'd also be able to figure out –

'Why Dinah Shore DOESN'T HAVE A
 PROBLEM.'

I would also be thrilled to be able to know what color
eyes a person has just from looking at them, because
color TV still can't help you too much there.

Certain people have TV magic: they fall completely
apart off-camera but they are completely together on-
camera. They shake and sweat before they go on, they
shake and sweat during commercials, they shake and
sweat when it's all over; but while the camera is filming
them, they're poised and confident-looking. The camera
turns them on and off.

I never fall apart because I never fall together. I just sit
there saying 'I'm going to faint. I'm going to faint. I
know I'm going to faint. Have I fainted yet? I'm going

to faint.' When I'm on television I can't think about any-
thing they're going to ask me, I can't think about
anything that's going to come out of my mouth – all I
can think is, 'Is this a live show? It is? Well then forget it,
I'm going to faint. I'm waiting for a faint.' That's my live
television appearance stream-of-consciousness. Taped is
different.

And I always thought that talk-show hosts and other
television personalities could never know what it's like
to feel that nervous, but then I realized that some of
them might actually have a variation of the same
problem – maybe every minute they're thinking 'I'm
going to blow it, I'm going to blow it . . . there goes the
summer house in East Hampton . . . there goes the Park
Avenue co-op . . . there goes the sauna . . .' The differ-
ence is that while they're thinking their version of 'I'm
going to faint', they can somehow – through their TV
magic – keep pulling out the lines and stuff they have
stored somewhere.

There are some people who just begin performing when
they're 'on'. 'On' is different things to different people.
I was watching a young actor accepting his Emmy on
television and he went up there on the stage, and he
turned right on, he went right into his acting to say,
'I want to say thanks, thanks to my wife—' and he was

doing a 'meaningful moment' scene. He was having a ball. I started thinking what a big fantastic moment getting an award like that must be for a person who can only turn 'on' when he's in front of people. If that's what turns him on, when he gets that chance, he has to be up there feeling *fine*, thinking, 'I can do anything, anything, ANYTHING!'

So I guess everybody has their own time and place when they turn themselves on.

Where do I turn on?

I turn on when I turn off and go to bed. That's my big moment that I'm always waiting for.

'Good performers', I think, are all-inclusive recorders, because they can mimic emotions as well as speech and looks and atmosphere – they're more inclusive than tape recordings or videotapes or novels. Good performers can somehow record complete experiences and people and situations and then pull out these recordings when they need them. They can repeat a line exactly the way it should sound and look exactly the way they should look when they repeat it because they've seen the scene before somewhere and they've shelved it away. So they know what the lines should be and the way the lines should come out of them. Or stay in them.

I can only understand really amateur performers or really bad performers, because whatever they do never really comes off, so therefore it can't be phoney. But I can never understand really good, professional performers.

Every professional performer I've ever seen always does exactly the same thing at exactly the same moment in every show they do. They know when the audience is going to laugh and when it's going to get really interested. What I like are things that are different every time. That's why I like amateur performers and bad performers – you can never tell what they'll do next.

Jackie Curtis used to write plays and stage them on Second Avenue, and the play would change every night – the lines and even the plot. Only the name of the play would stay the same. If two people saw the show on different nights and started talking about it to each other, they found out that nothing was the same in the two shows. The runs of these plays were 'evolutionary', as the play kept changing all the time.

I know that 'professional' is fast, and it's good, and people are on time, and they show up, and they do it right, and they're on key, and they do their numbers, and there are no problems. You watch them perform and they look so natural you just can't believe they're not

ad-libbing – it looks like the funny line just occurred to them at the moment they said it. But then you go to see them the next night and the same funny line is just occurring to them all over again.

If I ever have to cast an acting role, I want the wrong person for the part. I can never visualize the right person in a part. The right person for the right part would be too much. Besides, no person is ever completely right for any part, because a part is a role is never real, so if you can't get someone who's perfectly right, it's more satisfying to get someone who's perfectly wrong. Then you know you've really got something.

The wrong people always look so right to me. And when you've got a lot of people and they're all 'good', it's hard to make distinctions, the easiest thing is to pick the really bad person. And I always go after the easiest thing, because if it's the easiest, for me it's usually the best.

I was doing a commercial the other day for some sound equipment, and I could have pretended to say all the words they gave me that I would never say that way, but I just couldn't do it.

When I played an airport person in a movie with Elizabeth Taylor the lines they gave me were something like 'Let's go. I have an important date', but it kept coming

out of my mouth, 'Come on, girls.' But in Italy they dub everything in afterwards, so no matter what you don't say, you say it anyway.

I did an airline commercial once with Sonny Liston – 'If you've got it, flaunt it!' I liked saying that, but then later they dubbed my voice, although they didn't dub his.

Some people say that you're only impressed with some-body famous if you've known about them since you were little or for a long time before you met them. They say that if you've never heard of an individual and you meet them, and then afterwards somebody comes over and tells you that you've just met the richest, most famous person in, say, Germany, you would not be so impressed at having met them, because you yourself had never put any of your own time into thinking about how famous they are. However, *I feel just the opposite*: I'm not impressed with all these funny people that everybody thinks are famous, because I always feel they're the easi-est to meet. What I'm most impressed with is when I meet somebody I thought I could never meet – that I'd never dream I'd be talking to some day. People like Kate Smith, Lassie, Paloma Picasso's mother, Nixon, Mamie Eisenhower, Tab Hunter, Charlie Chaplin.

When I was little I used to listen to The Singing Lady

on the radio all the time while I was in bed coloring. Then in 1972 I was at a party in New York and I was introduced to a woman and they said, 'She used to be The Singing Lady on the radio.' I was just incredulous. I could hardly believe that I was really meeting her, because I never dreamed that I would ever meet her. I'd just assumed that there was no chance at all. When you meet someone you never dreamed you'd meet, you're taken by surprise, so you haven't made up any fantasies and you're not let down.

Some people spend their whole lives thinking about one particular famous person. They pick one person who's famous, and they dwell on him or her. They devote almost their entire consciousness to thinking about this person they've never even met, or maybe met once. If you ask any famous person about the kind of mail they get, you'll find that almost every one of them has at least one person who's obsessed with them and writes constantly. It feels so strange to think that someone is spending their whole time thinking about you.

Nutty people are always writing me. I always think I must be on some nutty mailing list.

I always worry that when nutty people do something, they'll do the same thing again a few years later without ever remembering that they've done it before – and they'll think it's a whole new thing they're doing. I was

shot in 1968, so that was the 1968 version. But then I have to think, 'Will someone want to do a 1970s remake of shooting me?' So that's another kind of fan.

In the early days of film, fans used to idolize a *whole* star – they would take one star and love everything about that star. Today there are different fan levels. Now fans only idolize *parts* of the stars. Today people can idolize a star in one area and forget about him in another. A big rock star might sell millions and millions of records, but then if he makes a bad movie, and when the word gets around that it's bad, forget it.

New categories of people are now being put up there as stars. The sports people are making themselves into great new stars. (Something I think about when I'm watching things like Olympic meets is 'When will a person not break a record?' If somebody runs at 2.2, does that mean that people will next be able to do it at 2.1 and 2.0 and 1.9 and so on until they can do it in 0.0? So at what point will they not break a record? Will they have to change the time or change the record?)

Nowadays if you're a crook you're still considered up-there. You can write books, go on TV, give interviews – you're a big celebrity and nobody even looks

down on you because you're crook. You're still really up-there. This is because more than anything people just want stars.

Good b.o. means good 'box office'. You can smell it from a mile away. The more you spell it out, the bigger the smell, and the bigger the smell, the more b.o. you get.

Working for a lot of money can throw your self-image off. When I used to do shoe drawings for the magazines I would get a certain amount for each shoe, so then I would count up my shoes to figure out how much I was going to get. I lived by the number of shoe drawings – when I counted them I knew how much money I had.

Models can sometimes be very rude. Because they get paid by the hour and put in their eight-hour day, when they go home they think they should still be getting paid. Movie stars get millions of dollars for nothing, so when someone asks them to do something for nothing, they go crazy – they think that if they're going to talk to somebody at the grocery store they should get fifty dollars an hour.

So you should always have a product that's not just 'you'. An actress should count up her plays and movies

and a model should count up her photographs and a writer should count up his words and an artist should count up his pictures so you always know exactly what you're worth, and you don't get stuck thinking your product is you and your fame, and your aura.